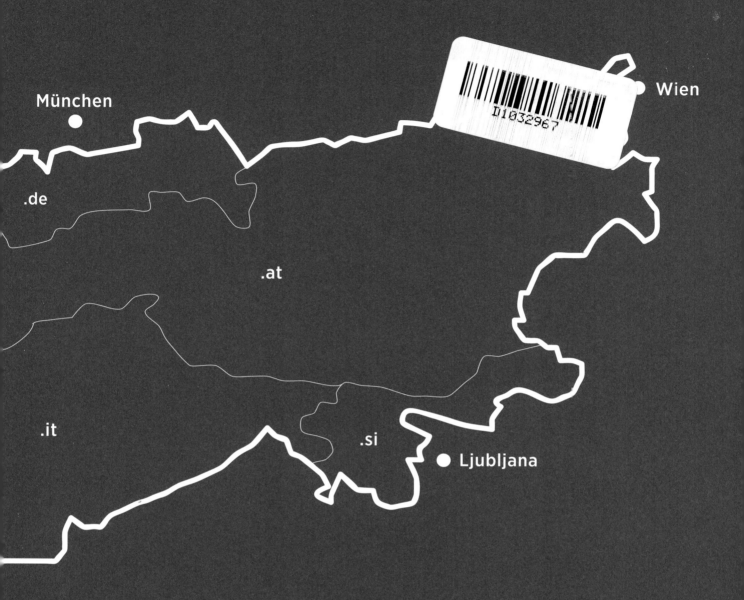

München

.de

.at

.it

.si

Ljubljana

Wien

I1032967

THE ALPS

THOMAS KNEUBÜHLER
ALPINE SIGNALS

TWENTYSIX CELL TOWERS
IN THE ENGADIN

WITH TEXTS BY | MIT TEXTEN VON | AVEC DES TEXTES DE
ROMANA GANZONI & REBECCA DUCLOS

VERLAG FÜR MODERNE KUNST

**ROMANA GANZONI
LOOK, THE GAS PUMPS!**

My short story *Der Kanister* (The Gas Can) is about Bruna, whose car, a Suzuki, suddenly stops in the mountain landscape of the Engadin "out of gas, in a desolate place, on a pass, in the middle of an Alpine cliché." There is not even a cell tower nearby: "A flurry of snow had set in, no reception, neither phone nor radio; on the other side, in the north, it would work again."

A situation taken from real life in the Alps. It's obvious that lack of fuel and no reception can end in disaster, at least in some circumstances. Nature might eventually lend assistance, but an "Alpine cliché"? This conclusion, which comes from my aversion to the rhetoric of the sublime and the bombastic, offers the photographs assembled here a warm welcome.

This is my valley. I do not want to deny or glorify it. This is my river. The mountains. Were there before me, a reality out of stone ever since I can remember. Sometimes like a wall, then a barrier. Me. As if I were a part of them. I did not assist the Creator or facilitate evolution; I contributed nothing to these fold mountains. Of course, it is amazing to look into the valley after a strenuous hike, but it is even more amazing to read Thomas Mann's *Buddenbrooks,* to be familiar with the poems of Luisa Famos or to follow a complicated recipe, to put a feast on the table. Lending a neighbour an egg. Gaze into beautiful eyes.

Does looking down from the mountain into the valley make me richer? In my case: no. But I managed the hike. That remains. To be able to succeed, not giving up because of a cramp, hunger, thirst, dislike. The gaze downward, the overview, being at the top makes me feel exhilarated, but am I purified because of it? No. Does contemplating nature advance me in a technical, religious, artistic, moral, or intellectual way? No. Is it restorative? Yes. It is restorative. And it

is beautiful. How beautiful this landscape is! Who would want to leave it? I do. Sometimes. By car, bus, or train. And online. For that, I need gas, a train ticket, electricity, a battery, reception.

The images in this book do not sentimentalize or chasten nature; they would not ban gas stations or cell towers from the landscape, no matter how bizarre and strange. On the contrary. It is about them— and their relevance. Someone else took pictures of gas stations in the last century, Ed Ruscha, for instance. They resonate in the title of this book; their smell approaches me, twenty-six times, how I love it! A number, reference, and homage: *Twentysix Gasoline Stations,* a photographic road trip, today just as celebrated as it is legendary. Does this mean we accompany Kneubühler, on another continent, not on a road trip but a hike—or a pilgrimage? In Europe. Münstertal, Lower Engadin, Samnaun. Why not? We are taking this walk, coming from the Italian border, through Switzerland in the direction of Austria. My thoughts follow this walk and at the same time follow themselves.

We walk off the beaten path, far from the beautiful view; we walk from non-place to non-lieu, like the mountain pass road in the above-mentioned short story, not suitable for lingering, a negotiation of obstacles, simultaneously connecting different cultures. A pass that perhaps shapes the locals more than the mountain. Thomas Kneubühler also had to conquer the pass and the tunnel road cut into the rocks in order to connect his three valleys. From *cell tower* to *cell tower,* from *Mobilfunkantenne* to *Mobilfunkantenne,* from *indriz da telefonia mobila* to *indriz da telefonia mobila.* The English expression is powerful, dominant and clear, no question; the German or Romansh terms sound as cumbersome and ugly as other manifestations of such a structure—along with the delicate variety: it can even be playful, attractive, like a sculpture, or as if it was there for the purpose of receiving mysterious signals from outer space.

Does it bring a wayside cross to mind? Perhaps. Except there is by no means always a path—between trees, mountains, and horses there are antennas, on meadows, mounted on other buildings: dam, power plant, loading dock for the auto train, ski lift station, church. Top of the pass, ski slope, captured in sunlight and greenery, in the snow and at twilight, the implicit power made visible. Look at me, acknowledge that you are only able to take photographs of the alpine world with your smartphone thanks to me. Because I am there, you can post your enchanting images of nature on Instagram. I provide your hashtags #virginnature #mountainworld #paradise #sunset #winterwonderland.

I, the antenna, make sure you can multitask on the go; depending on how many apps you open, you can browse, buy online, cancel an appointment, coordinate a meeting, do business, sign a petition; be active on Facebook, send a Tweet, upload the perfect sunrise on Instagram, then report on LinkedIn that an essay is being written for an art book that everyone should buy. In addition, you can call your father or—with or without an image—chat with friends, son and daughter, while the cell tower in a—mostly hidden—place does its job, steadily and reliably. Next to you is the physical reality of all these escapades.

There is a price for all of this some will say, that this book does not accurately reflect the Engadin—a bit atypical. Because cell towers disturb, not only aesthetically; on photographs of the Engadin there are mountains, if there has to be a town, then please a sleepy village, but no high-voltage power line, no snow groomer, or remnants of a strangely furnished landscape in the off-season. Every cell tower is like a little off-season, a hybrid situation, annoying but necessary; without them there would be no summer, no winter. No money. This non-time, this non-season is like the non-place that constitutes the station and the cell tower.

If extraterrestrials came along off-season, they could speculate about it. They would wave their slender fingers and squeal with delight at the sight of the abandoned lifts that remind them of UFOs. Shelters and antennaesque forms everywhere. Do the ski lift masts serve the purpose of picking up extraterrestrial melodies? And the other structures? Who bounced on these orange pads? Who lay in the red safety nets between the former ski slope and the village? What kind of giant parchment scroll was transported through the transparent secret pipes?—Most certainly not suitable for the photo album. Or maybe so? Above all, because it's interesting? For everything else, there are postcards at the gift shop.

In any case, after intense contemplation of cell towers I cannot justify my aesthetic aversion to objects that I initially perceived as invasive species; I welcome them not only as killers of the sublime but also as space-creating forms ordered in lines indicating a symbolic path, from antenna to antenna, as if not only human beings would communicate with their smartphones—fed by them—and start their searches; the cell towers do the same, in an encrypted connection through valleys and peaks. Like the church steeples from the past, that were elite, chosen and linked to the heavens, the towers also acknowledge the vertical. The towers served this practical purpose as tall buildings announcing fires and other dangers up and down the valley. A medium for essential, in fact, existential information that over the course of centuries has become likewise banal, despite its ease and speed. No wonder that the first transatlantic telegraph message reported: *"Princess Adelaide has the whooping cough."* Today, an emoji is often enough.

Now the antenna points upwards, without a cross, rooster, or star. Even though no hand extends to another, there is help and a closeness with buildings, and also the growing, flourishing, stagnating,

or dying flora and fauna. The antennas connect with each and every one, they guarantee equal exchange in every direction—in buildings, on chairlifts, in streets; while mushroom picking, while hunting. We wander alongside these modern wayside crosses, a Via Dolorosa without suffering, in nearly twice as many stations as the Way of the Cross. Yet here, too, the essence is invisible—ethereal, perhaps even suppressed. A wellspring journey of a very different kind, to the place that water does not flow but communication does. Look, the gas pumps!

In my short story *Der Kanister* the gas pumps are always present (for the replacement plot), but not accessible; they are on the other side, "of the moon" I almost want to add, in the north, unreachable for Bruna, who is stranded and must wait. I had to do it to her, cut her off from civilization, so her inner worlds bury her in rubble— up to the bitter end? Bruna's mother appears in the back seat and gives her daughter a gas can and matches. She probably means, blow yourself up, because you are out of your mind. No reception, no supply means no help. In other words, you are alone. Abandoned. Because even the postmodern individual cannot live by bread alone. It doesn't help to look at the mountains and the running cows. A nightmare starts in this total defenselessness. If there had been a charged battery and a cell connection, Bruna would have certainly amused herself with *Candy Crush* until help arrived.

ROMANA GANZONI
SCHAUT, DIE ZAPFSÄULEN!

In meiner Erzählung *Der Kanister* geht es um Bruna, deren Wagen, ein Suzuki, in der Engadiner Berglandschaft stehen bleibt, «das Benzin war ausgegangen, in der Einöde, auf dem Pass, mitten im Alpenklischee». Auch gibt es offensichtlich keine Mobilfunkantenne in der Nähe: «Schneegestöber hatte eingesetzt, kein Empfang weit und breit, weder Telefon noch Radio, auf der anderen Seite, im Norden, würde es wieder klappen.»

Eine Situation, aus dem Leben in den Alpen gegriffen. Dass fehlender Treibstoff und kein Empfang unter Umständen in die Katastrophe führen, liegt auf der Hand. Die Natur könnte allenfalls Hilfe bieten, aber ein «Alpenklischee»? Diese Wertung, die aus meiner Abneigung gegen Erhabenheitsrhetorik und Pathos floss, bietet den hier versammelten Fotos ein warmes Willkommen.

Mein Tal ist mein Tal. Ich will es weder loswerden noch verherrlichen. Mein Fluss ist mein Fluss. Die Berge. Waren vor mir da, Realität aus Stein, seit ich denken kann. Manchmal wie eine Mauer, dann wie ein Schutzwall. Ich. Als wäre ich ein Teil davon. Ich habe dem Schöpfergott nicht assistiert und die Evolution nicht begünstigt, ich habe rein gar nichts zur Gebirgsfaltung beigetragen. Klar, es ist toll, ins Tal zu schauen nach einer beschwerlichen Wanderung, aber es ist noch toller, *Die Buddenbrooks* von Thomas Mann zuzuschlagen, die Gedichte von Luisa Famos zu kennen oder ein kompliziertes Rezept einzuhalten, ein Festmahl auf den Tisch zu stellen. Der Nachbarin ein Ei leihen. In schöne Augen schauen.

Macht mich der Blick vom Berg ins Tal hinab reicher? In meinem Fall: nein. Aber ich habe die Wanderung geschafft. Das bleibt. Es schaffen können, nicht aufgeben wegen eines Krampfs, wegen Hunger, Durst oder Unlust. Der Blick nach unten, die Übersicht, das Obensein erlauben ein gutes Gefühl, aber bin ich deshalb geläutert oder edler? Nein. Bringt mich die Naturbetrachtung technisch, religiös, künstlerisch,

moralisch oder intellektuell weiter? Nein. Ist es erholsam? Ja. Es ist sehr erholsam. Und es ist schön. Wie schön ist doch diese Landschaft! Wer will hier weg? Ich. Manchmal. Mit Auto, Bus oder Zug. Und virtuell. Dazu brauche ich Benzin, eine Fahrkarte, Elektrizität, Akku, Empfang.

Die Bilder in diesem Buch verkitschen und verkeuschen die Natur nicht, sie würden weder Tankstellen verbannen, noch verbannen sie Antennen aus der Landschaft, seien sie noch so bizarr und fremd. Im Gegenteil. Es geht um sie – und ihre Bedeutung. Die Tankstellen hat ein anderer aufgenommen, im letzten Jahrhundert, Ed Ruscha, sie klingen im Titel dieses Buches mit, ihr Geruch kommt mir entgegen, sechsundzwanzigfach, wie ich ihn liebe!, als Ziffer, Referenz und Hommage: *Twentysix Gasoline Stations,* eine Art fotografischer Road-trip, heute so gefeiert wie legendär. – Heisst das, wir gehen mit Kneubühler, auf einem anderen Kontinent, nicht zum Roadtrip, son-dern wandern – oder pilgern? In Europa. Münstertal, Unterengadin, Samnaun. Warum nicht? Wir bewegen uns also auf diesem Spazier-gang, von der italienischen Grenze herkommend, durch die Schweiz Richtung Österreich. Meine Gedanken machen diesen Spaziergang mit und folgen gleichzeitig sich selbst.

Wir gehen abseits der Attraktionen, abseits der schönen Aussicht, wir gehen vom Nichtort zum Non-Lieu, wie es auch die Passstrasse in der oben erwähnten Erzählung ist, eine Durchgangsstrasse, nicht zum Verweilen geeignet, eine Überwindung von Hindernissen, gleich-zeitig Verbindung von Kulturräumen. Der Pass, der die Einheimischen vielleicht mehr prägt als der Berg. Auch Thomas Kneubühler musste den Pass und die in Felsen gehauene Tunnelstrasse überwinden, um seine drei Talschaften zu verbinden. Von *Cell Tower* zu *Cell Tower,* von Mobilfunkantenne zu Mobilfunkantenne, von *indriz da telefonia mobila* zu *indriz da telefonia mobila.* Der englische Begriff hat Kraft, ist dominant und klar, keine Fragen, der deutsche oder der rätoroma-nische Begriff klingt so sperrig und hässlich wie manche Ausprägung

dieses Anlagetyps – nebst der filigranen Sorte, er kann sogar verspielt sein, attraktiv, wie eine Skulptur, oder als sei er dazu da, mysteriöse Signale aus dem Weltall zu empfangen.

Erinnert er an ein Wegkreuz? Vielleicht. Nur ist da längst nicht immer ein Weg – zwischen Bäumen, Bergen und Pferden stehen die Antennen, auf Wiesen, an andere Bauten montiert, Staudamm, Kraftwerk, Autoverlad, Bergstation, Kirche, auf Passhöhe, Piste, bei Sonne und Grün, im Schnee und in der Dämmerung eingefangen, die implizite Definitionsmacht sichtbar machend: Sieh mich an, nimm zur Kenntnis, dass du die Bergwelt mit dem Smartphone nur fotografieren kannst dank mir. Weil ich da bin, kannst du deine zauberhaften Naturbilder auf Instagram posten. Ich sorge für deine Hashtags #bergwelt #unberührtenatur #paradies #winterwonderland #sunset.

Ich, die Antenne, sorge dafür, dass du multipel unterwegs sein kannst, je nachdem, wie viele Fenster offen stehen, kannst du konsumieren, den Onlinekauf abwickeln, einen Termin absagen, das Meeting koordinieren, Geschäfte anfüttern, Aktivismus mimen, du kannst als grüner Punkt auf Facebook sein, Gesprächsteilnehmerin bei Twitter, präsent mit dem neusten Foto des perfekten Sonnenaufgangs auf Instagram, du kannst gleich anschliessend auf LinkedIn rapportieren, dass ein Essay für einen Kunstband entsteht, den man bitte kaufen soll, dazu kannst du mit deinem Vater telefonieren oder – mit oder ohne Bild – mit Freunden, Sohn und Tochter plaudern, währenddessen der Mobilfunkmasten an einem – meistens verborgenen Ort – seinen Dienst tut, stabil und verlässlich. Er ist, neben dir, die physische Realität all dieser Eskapaden.

Der Preis dafür seien diese Dinger, werden die einen sagen, und dass dieses Buch das Engadin nicht richtig wiedergebe, untypisch halt. Weil Antennen stören, nicht nur ästhetisch, auf den Engadin-Bildern sind Berge, das schlafende Dorf zur Not, aber bitte keine Hochspannungs-

leitung, kein Pistenfahrzeug oder die Reste der seltsam möblierten Landschaft in der Zwischensaison. Jede Mobilfunkantenne sei wie eine kleine Zwischensaison, diese Zwittersituation. Zwischen den Jahreszeiten, irritierend, aber notwendig, ohne sie gäbe es keinen Sommer, keinen Winter. Kein Geld. Diese Nichtzeit, diese Unsaison ist wie der Unort, den Station und Funkzelle bilden.

Käme ein Ausserirdischer daher in der Zwischensaison, er könnte drauflos mutmassen. Er würde mit seinen mageren Fingern herumfuchteln und vor Freude quietschen bei der Sichtung ufoartiger Aufgänge ohne Funktion. Behausungen und Antennenartiges überall. Dienen die Skiliftmasten zur Aufgabelung extraterrestrischer Gesänge? Und die anderen Gerippe? Orange Dämpfkissen, wer hüpfte darauf? Wer lag in den roten Sicherheitsnetzen zwischen ehemaliger Skipiste und Dorf? Welche Riesenpergamentrolle wurde durch das durchsichtige Röhrengeheimnis spediert? – Ganz bestimmt nichts fürs Fotoalbum. Oder doch? Vor allem, weil interessant? Für den Rest gibt es doch Postkarten im Kiosk.

Nach intensiver Antennen-Betrachtung kann ich jedenfalls an meiner anfänglichen ästhetischen Abneigung gegen einige als Fremdkörper wahrgenommene Objekte nicht festhalten, ich nehme sie nicht nur wahr als willkommene Pathosklatschen, sondern als raumschaffende Gebilde, die in einer Abfolge stehen; sie zeichnet einen symbolischen Weg, von Antenne zu Antenne, als würden nicht nur die Menschen mit ihren Smartphones – von ihnen genährt – kommunizieren und ihre Suchen starten, die Antennen selbst tun das auch, in einer verschlüsselten Verbindung durch Täler und auf Höhen. Wie einst die Kirchtürme, die in Anerkennung des Vertikalen elitär, auserwählt, mit dem Himmlischen verbunden waren. Dazu dienten sie ganz praktisch als hohe Bauwerke, von denen aus Brände oder andere Gefahr angezeigt wurden, talauf- und talabwärts. Medium für essenzielle, gar existenzielle Informationen, die sich im Laufe der Jahrhunderte – im Gleichschritt mit den vereinfachten und beschleunigten Möglichkeiten –

entsprechend banalisiert haben. Kein Wunder, vermeldete das erste transatlantische Telegrafenkabel: *«Prinzessin Adelheid hat den Keuchhusten.»* Heute reicht oft ein Emoji.

Nun weist auch die Antenne nach oben, ohne Kreuz, Hahn oder Stern, und wenn auch keine ausgestreckte Hand zu sehen ist, die eine andere sucht, gibt es Hilfe und eine freundschaftliche Nähe zum Gebauten, aber auch zu der wachsenden, gedeihenden, stagnierenden oder sterbenden Flora und Fauna. Die Antennen connecten mit sich und jedem, garantieren für den demokratischen Austausch in alle Richtungen – in Häusern, auf Sesselliften, Strassen, zum Pilzesammeln, auf der Jagd. Wir wandern diesen modernen Wegkreuzen entlang, eine Via Dolorosa ohne Leiden, in fast doppelt so vielen Stationen wie der Kreuzweg. Aber auch hier ist das Wesentliche unsichtbar – ätherisch, vielleicht auch verdrängt. Eine Quellenwanderung der ganz anderen Art, zum Ort, der nicht Wasser zum Fliessen bringt, sondern Kommunikation. Schaut, die Zapfsäulen!

Auch in meiner Geschichte *Der Kanister* sind sie immer da, die Zapfsäulen (für die Ersatzhandlung), aber nicht zugänglich, sie liegen auf der anderen Seite, fast möchte ich «des Mondes» hinzufügen, im Norden, unerreichbar für Bruna, die gestrandet ist und warten muss. Ich musste es ihr antun, sie abschneiden von der Zivilisation, damit ihre inneren Welten auf sie einstürzen wie Geröll – bis zum tödlichen Ende? Auf dem Rücksitz taucht Brunas Mutter auf und reicht der Tochter einen Kanister und Zündhölzer. Spreng dich bitte in die Luft, heisst das wahrscheinlich. Denn du bist ja von allen guten Geistern verlassen. Kein Empfang, keine Zufuhr heisst keine Hilfe, heisst: Du bist allein. Verlassen. Denn auch der postmoderne Mensch lebt ja nicht vom Brot allein. Da hilft der Blick zu den Bergen und auf rennende Kühe nicht. In dieser totalen Schutzlosigkeit beginnt ein Albtraum. Wären da Akku und Verbindung gewesen, Bruna hätte sich bestimmt mit *Candy Crush* amüsiert, bis Hilfe gekommen wäre.

TWENTYSIX CELL TOWERS

Müstair

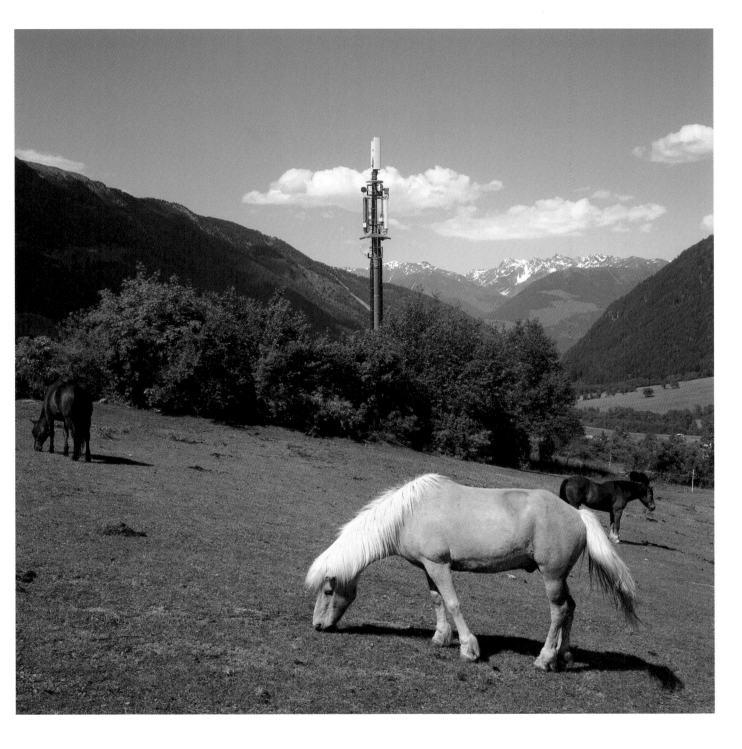

Pass d'Umbrail

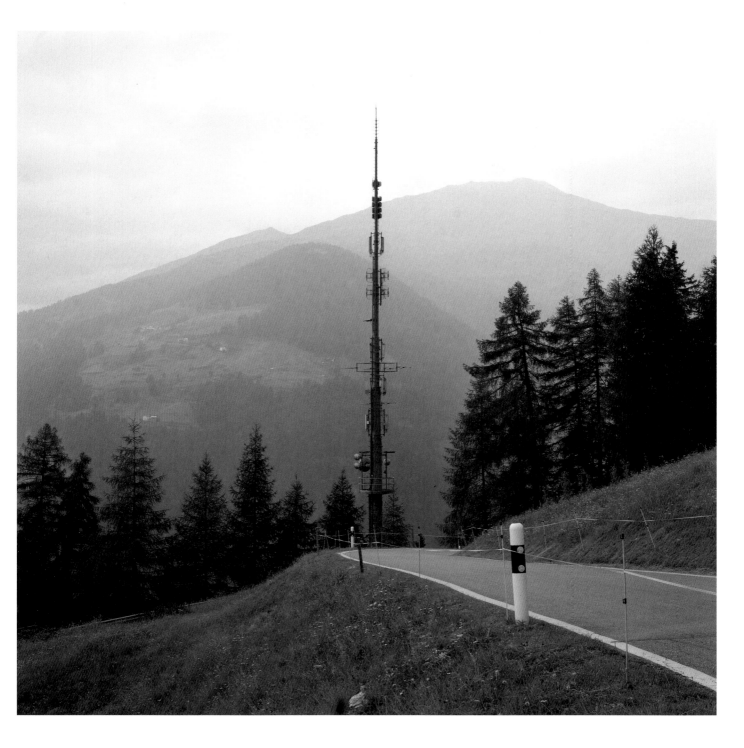

Multetta

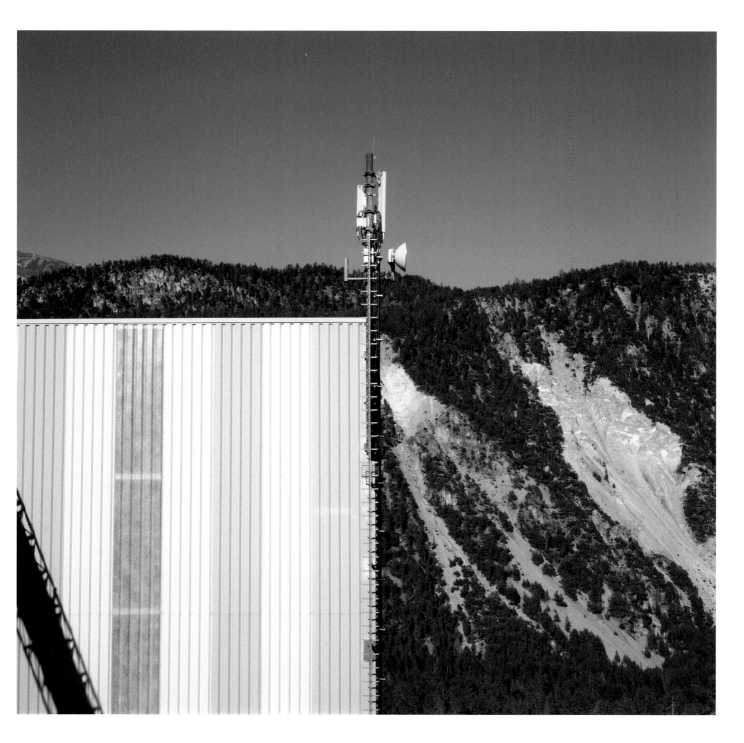

Pass dal Fuorn

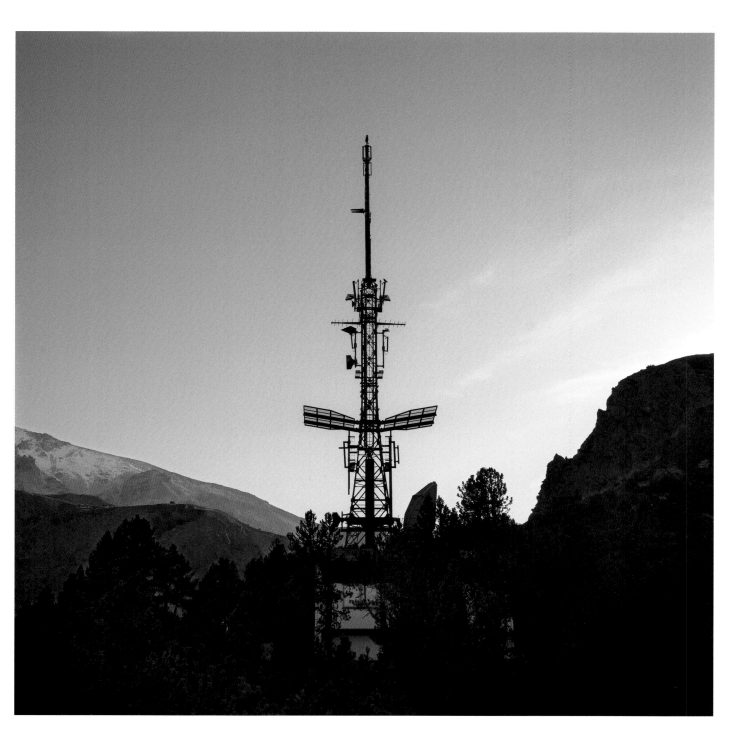

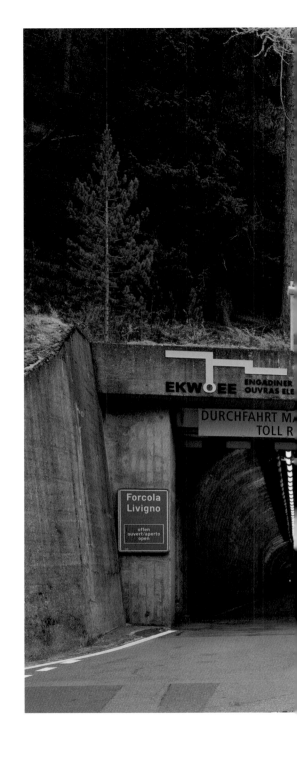

Punt la Drossa

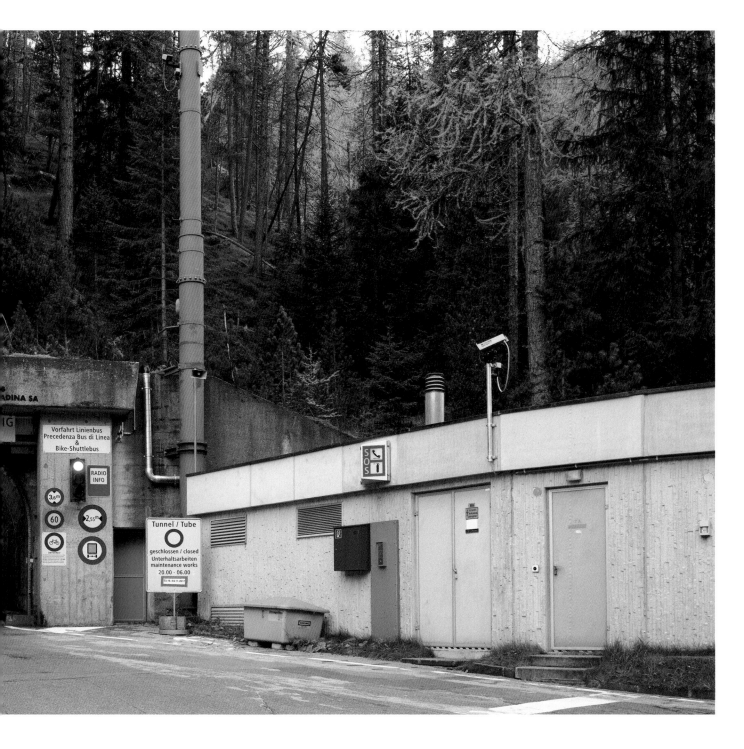

Punt dal Gall

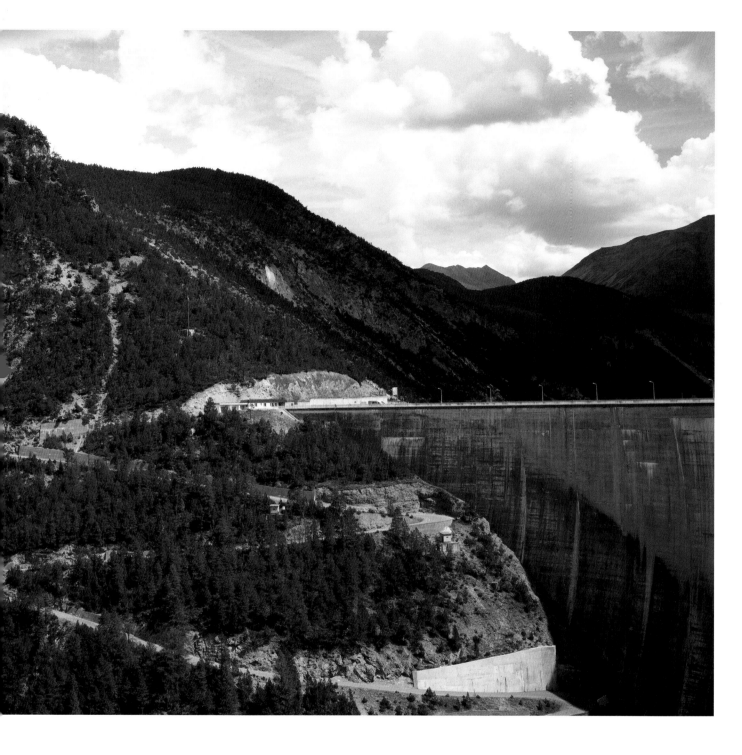

Il Fuorn

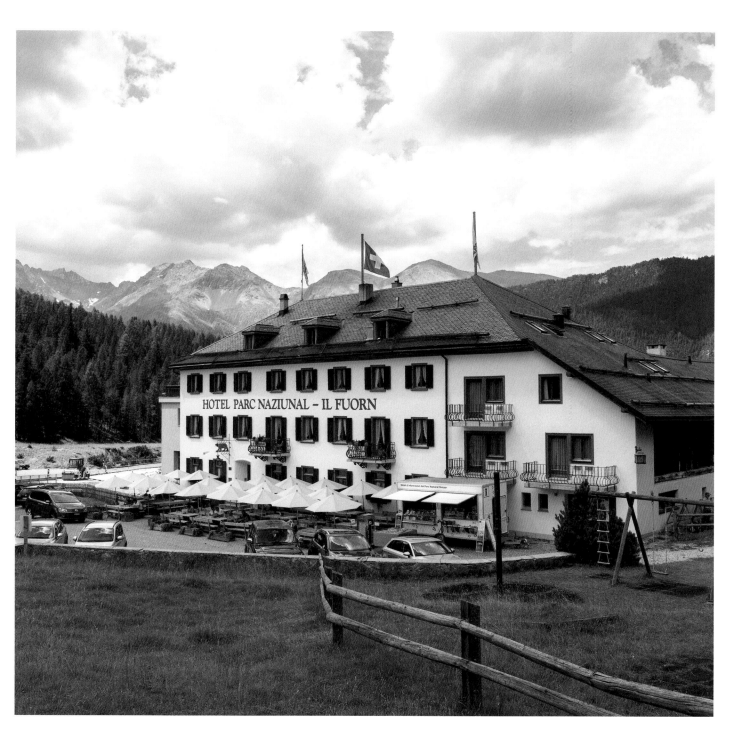

Ova Spin

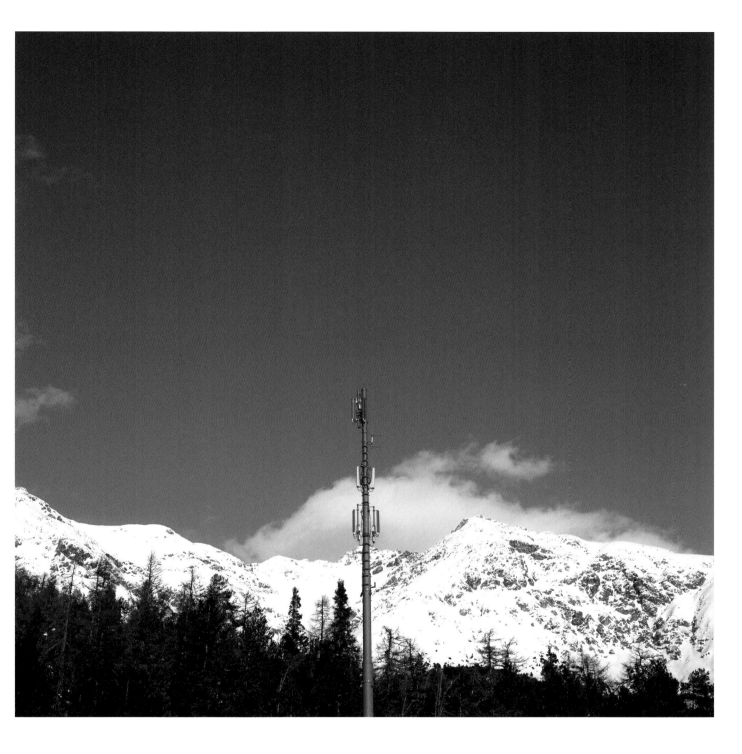

Zernez

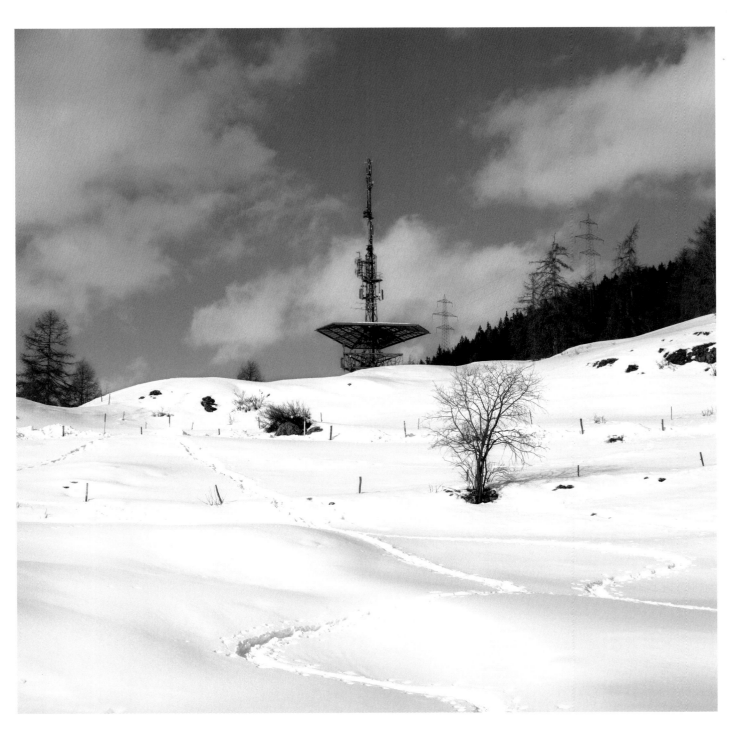

Susch

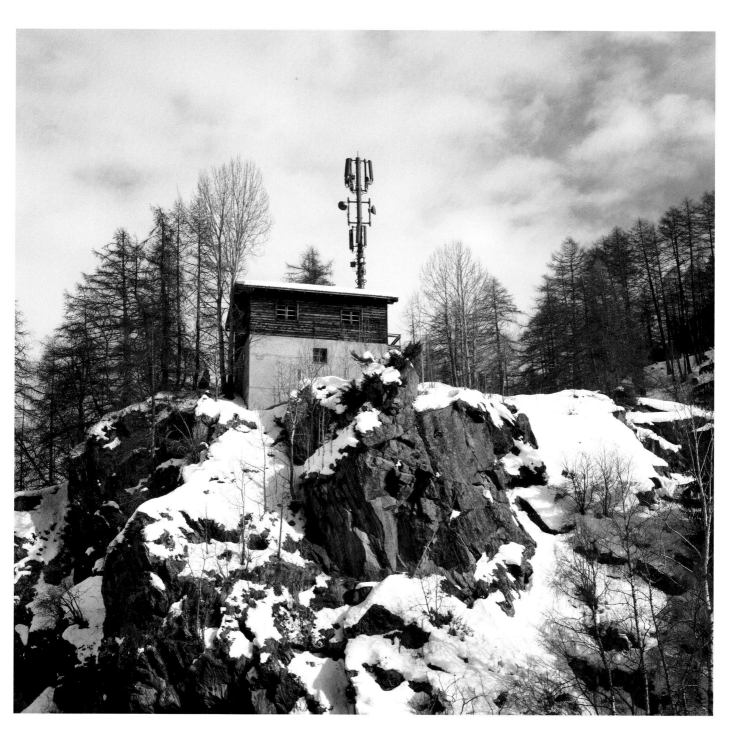

Saclians

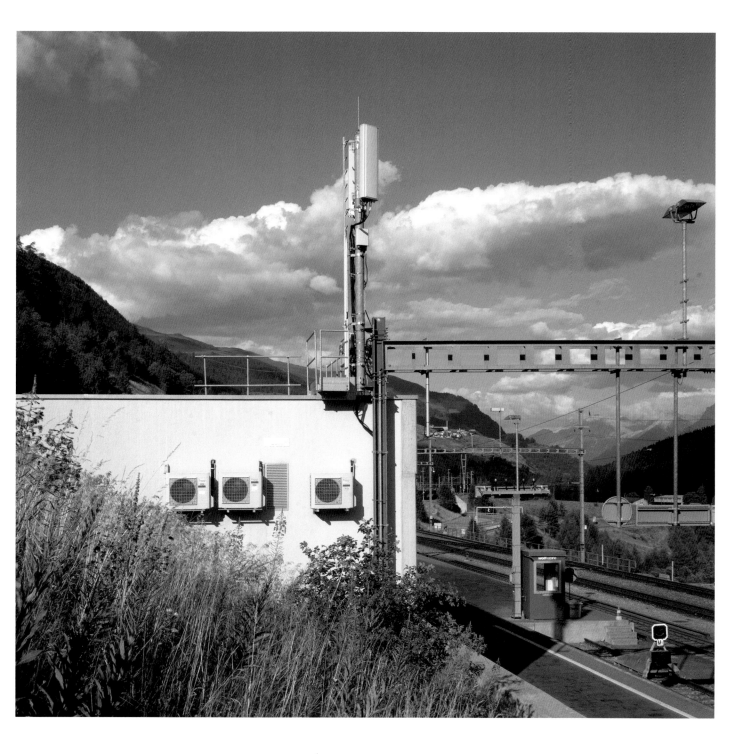

Chant Sura

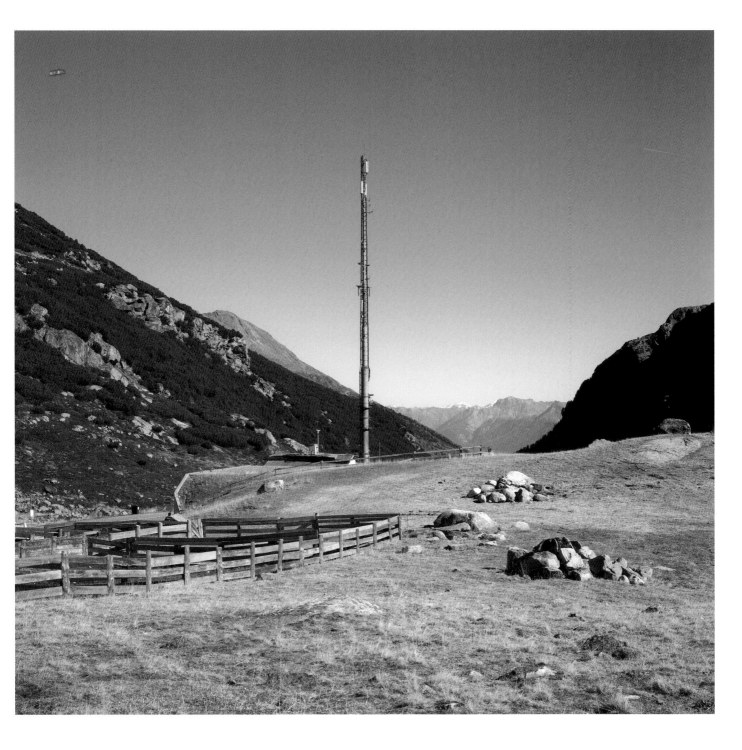

Nairs

Tarasp

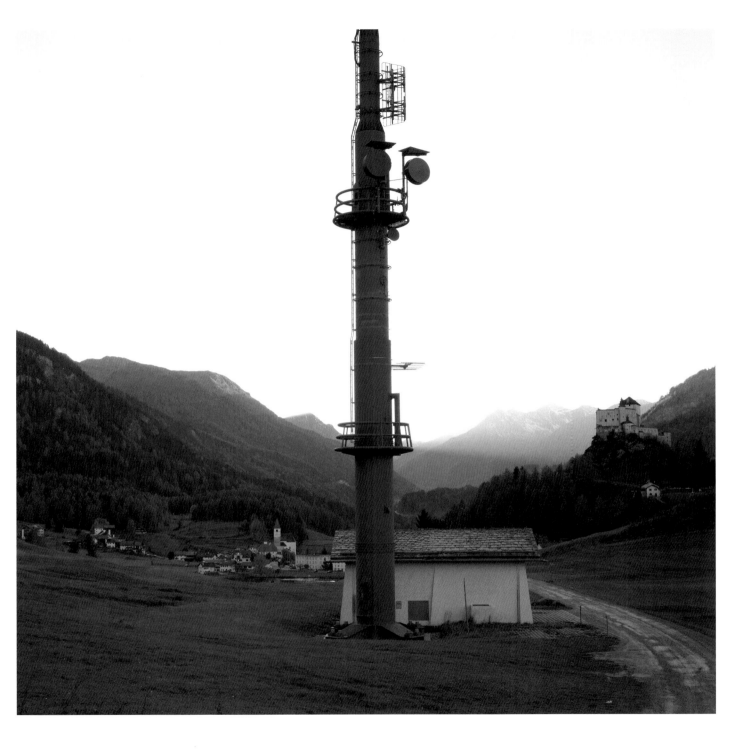

Vallaina

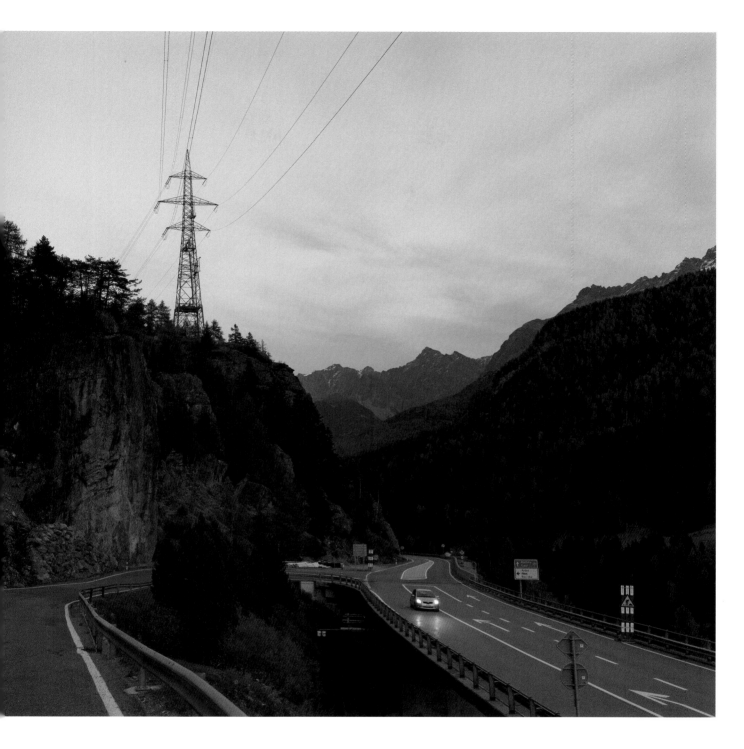

Scuol

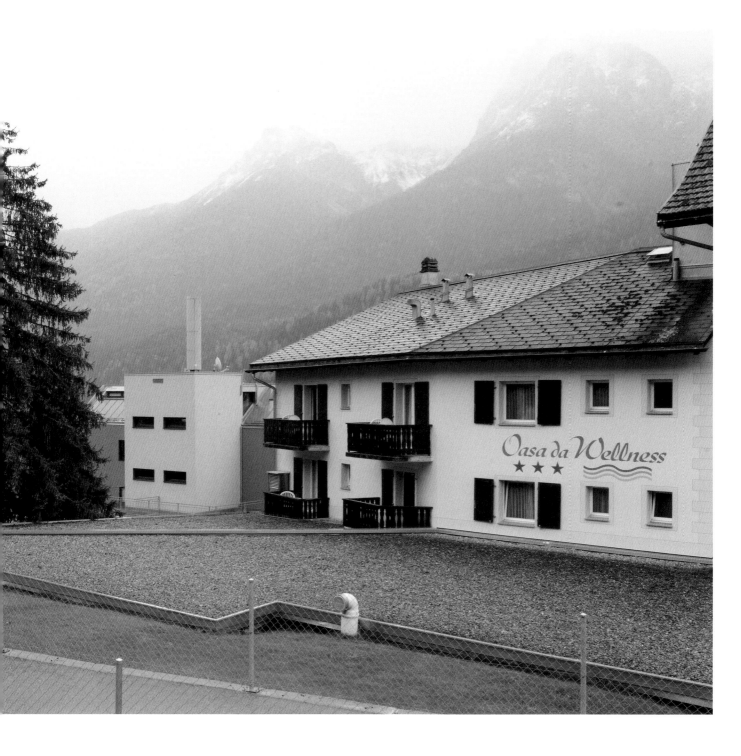

Gurlaina

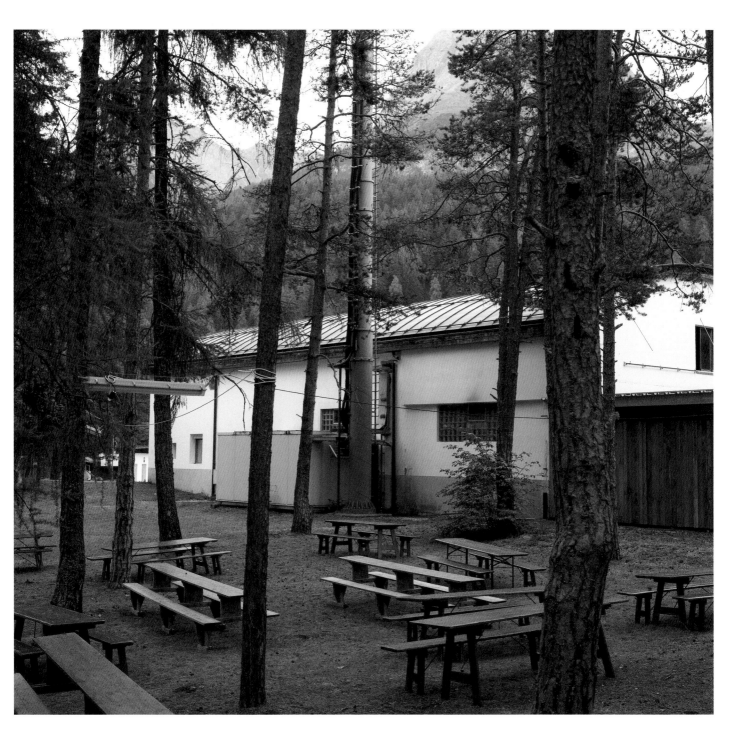

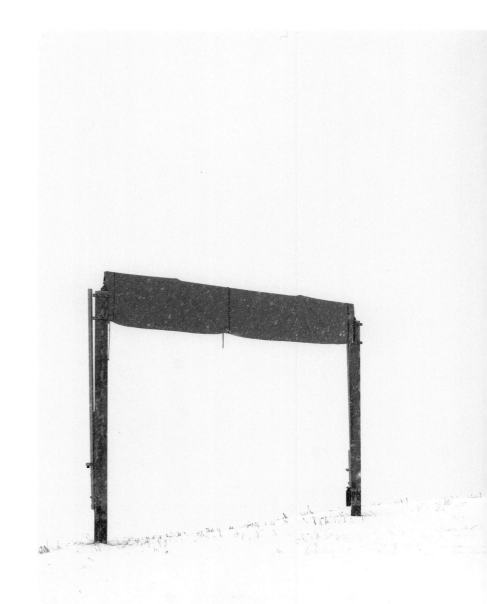

Naluns

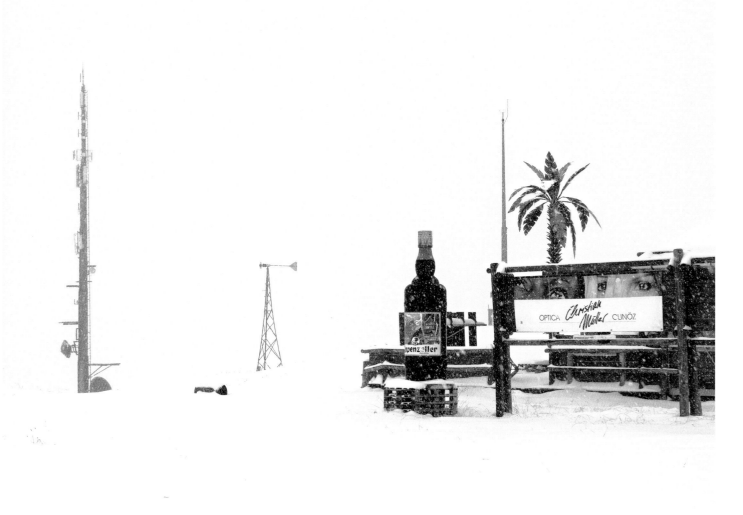

Sent

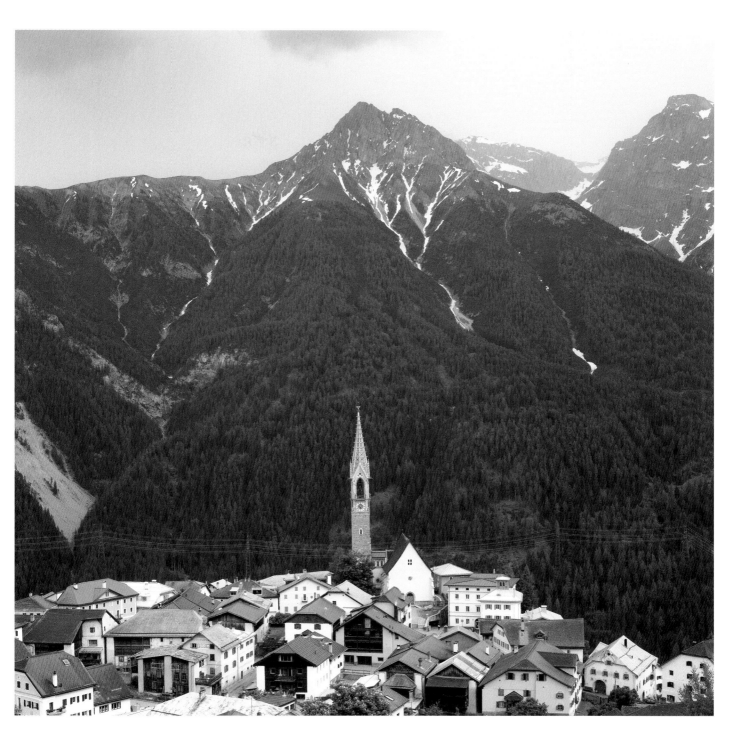

Spi da Vinadi

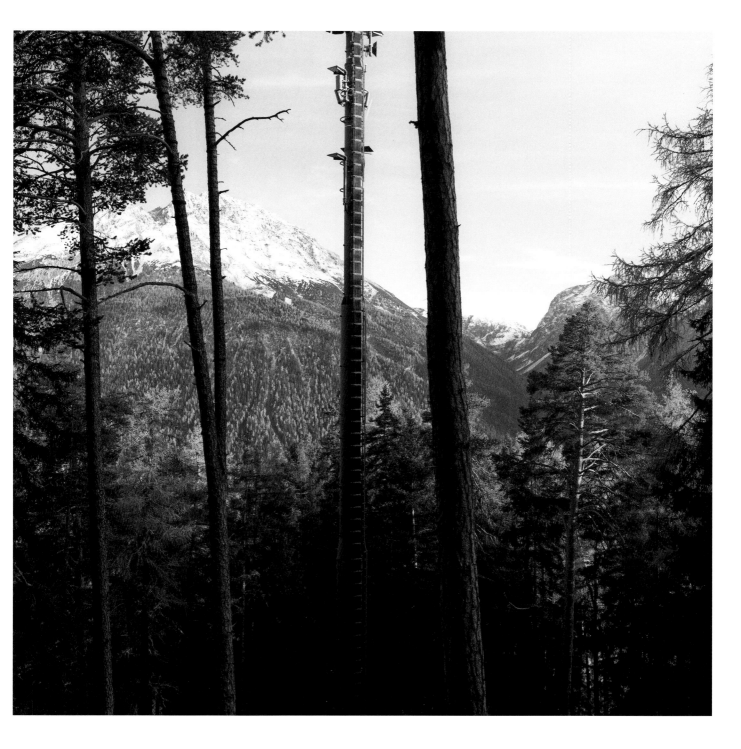

Farina Cotta

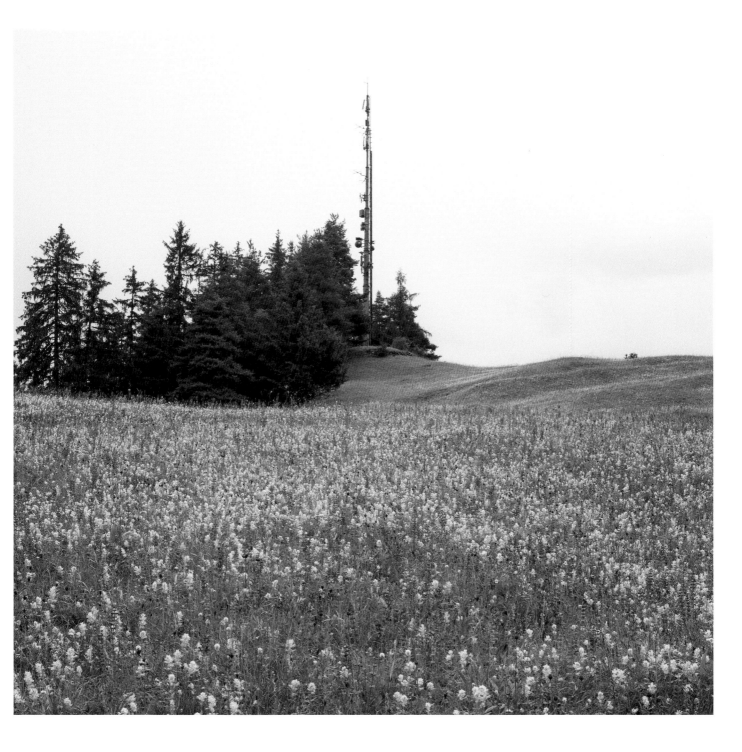

S-chalun

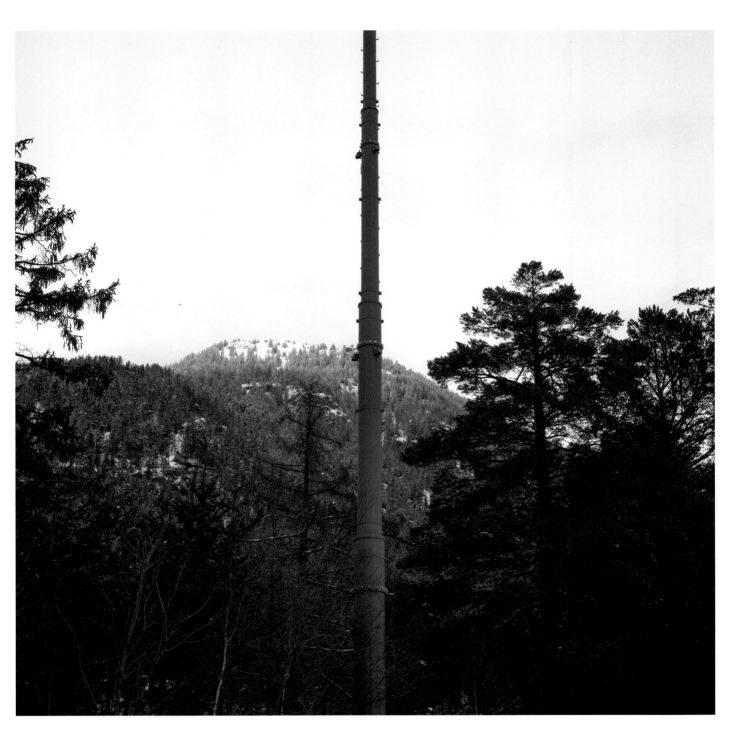

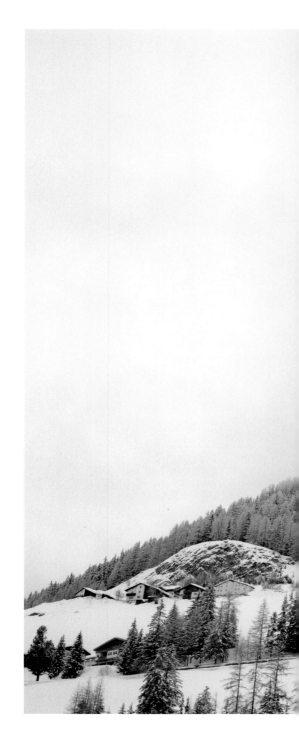

Acla da Fans

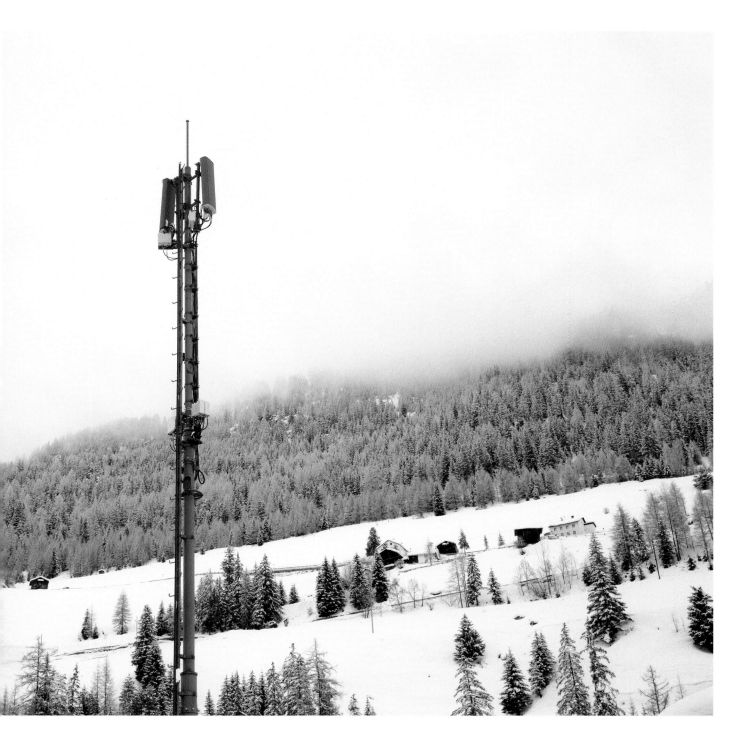

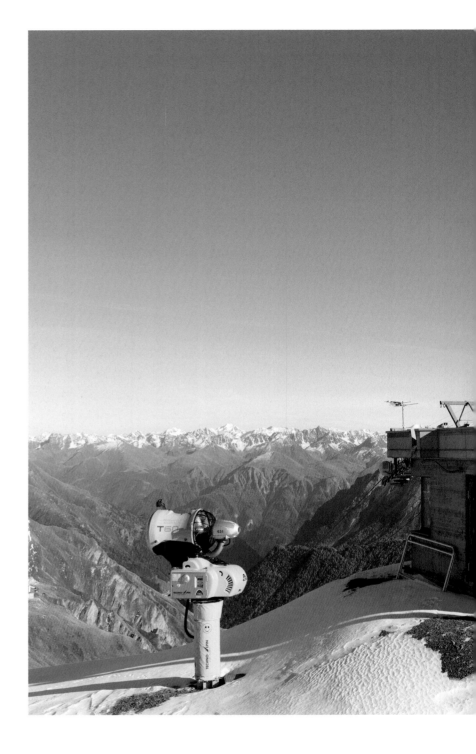

Greitspitz

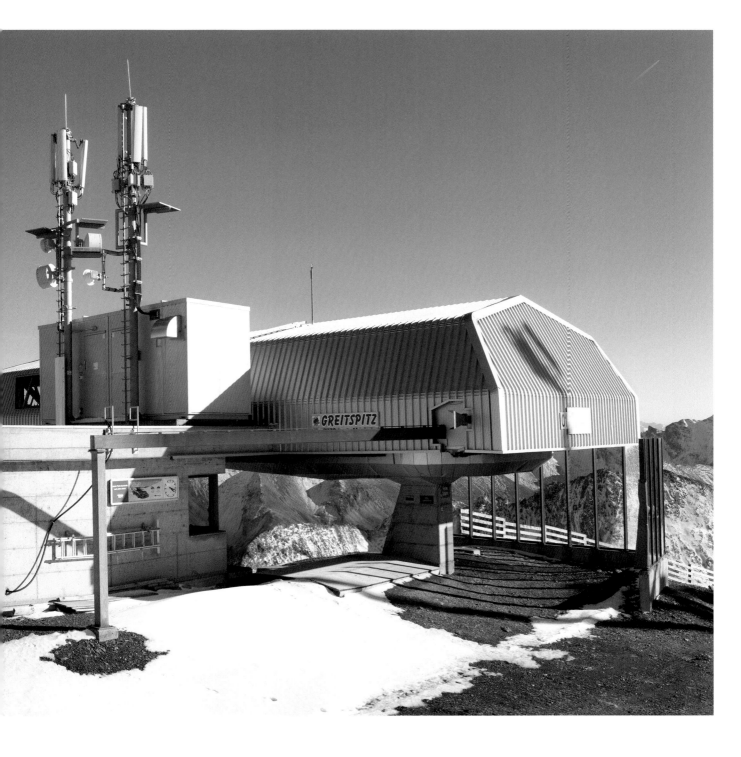

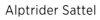

Alptrider Sattel

Samnaun

1	Müstair
2	Pass d'Umbrail
3	Multetta
4	Pass dal Fuorn
5	Punt la Drossa
6	Punt dal Gall
7	Il Fuorn
8	Ova Spin
9	Zernez
10	Susch
11	Saglians
12	Chant Sura
13	Nairs
14	Tarasp
15	Vallaina
16	Scuol
17	Gurlaina
18	Naluns
19	Sent
20	Spi da Vinadi
21	Farina Cotta
22	S-chalun
23	Acla da Fans
24	Greitspitz
25	Alptrider Sattel
26	Samnaun

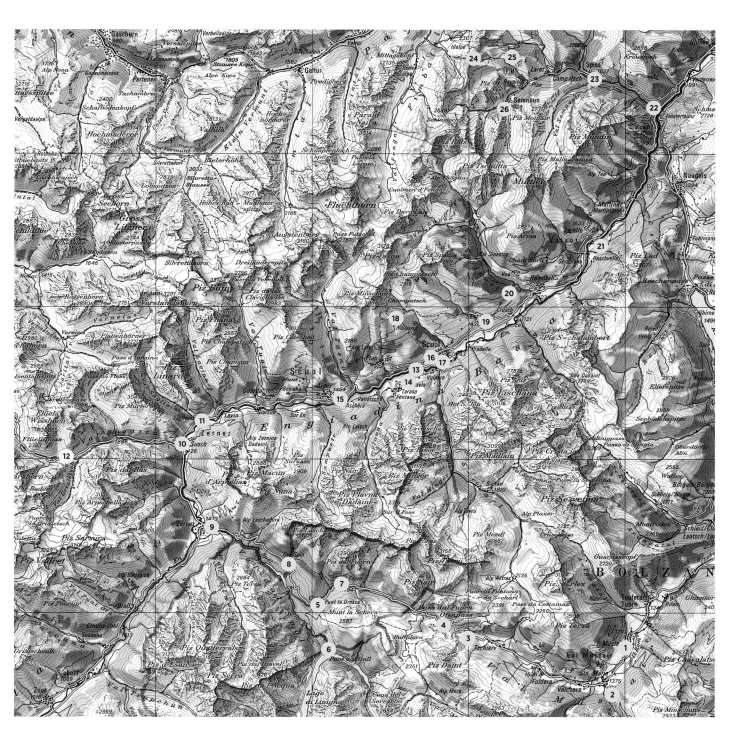

REBECCA DUCLOS
A DREAM. A BOY. A HORSE. A MIRROR.

Engadin! Engadin!
The round words in my mouth.
I woke up from my dream with a start.[1]

1 The Engadin is a high valley 100 kilometres long in the Swiss Alps that became the site of Thomas Kneubühler's repeated visits between 2017 and 2019. Published close to linear order here, the line of towers begins near the Italian border of Müstair and ends at a ski resort at Samnaun not far from Austria. A photographer experienced in orienteering, he used a publicly available map to guide him, but ultimately had to employ all manner of transport options (train, bus, car, bike, hiking) in order to reach this series of fairly remote towers. In the artist's own words, the project looks at "the intersection of society and technology, in this case the digitization of our life, which remains so often invisible." "My project," he goes on to say, "also poses questions about the genre of landscape photography. It made me go to places that no one else would choose as a destination—or photograph for that matter. Often they are *non-lieux,* which says more about the mountain region than many of the familiar picturesque views."

Personally, I've not yet had the pleasure of visiting the Alps, so I'm projecting myself into Thomas' world. Quite simply, what do I see? Each tower has a stark (some might say vulgar) solidity as an object in a landscape. I see vast tracts of land that are quintessentially "Swiss" in their ruggedness and quintessentially "Swiss" in their embrace of global entrepreneurship. What I don't see, of course—and what Thomas' images reference but can never capture—is the evanescent communications data streaming through the aether as an intangible Alpine wind. *This* is what I have been dreaming about since first seeing these photographs.

What do pictures want?[2]

Don't they want what everything wants?
To be seen. To be looked at.
How about looked through... not at.
You mean, like a window?
No—through—like through a telescope or through binoculars.
Nah. I think it's more like into.
The way you look into your lover's eyes.[3]

[2] *What do Pictures Want* is the provocative title of W. J. T. Mitchell's 2005 publication subtitled as *The Lives and Loves of Images.* At the end of his preface, it's as if Mitchell were looking at Thomas' photographs when he wrote: "A picture, then, is a very peculiar and paradoxical creature, both concrete and abstract, both a specific individual thing and a symbolic form that embraces a totality. To get the picture is to get a comprehensive, global view of a situation, yet it is also to take a snapshot at a specific moment—the moment when the click of a camera shutter registers the taking of a picture, whether it is the establishment of a cliché or stereotype, the institution of a system, or the opening of a poetic world (perhaps all three)." (Mitchell, 2005, p. xvii)

[3] The cell phone tower images do what good photographs do: they act paradoxically. Concretely, we can look at them with an admiration for their framing, their production, and their efficiency in capturing the Swiss landscape in all its historical Alpine cliché-ness dotted now with contemporary, capitalist, communication infrastructures. Abstractly, we can look *through* these photographs as they telescope us into a consideration of Thomas' body in particular spaces at particular times when he (in Mitchell's wonderfully old-fashioned terms) heard "the click of a camera shutter." Binocularly, though, I want to meld these two ways of looking "at" and "through" the pictures to consider how we might look into them or, after Denis Diderot, how we might *enter into them.* As into the eyes of a new lover, I stare deeply and ask *what do they want?* I think what these pictures want is to be both banal and sublime.

The sun was out. A walled-in, sunken surface teemed with kindergarteners. Our vantage point was from above.

"Look," my companion said "that little boy is lying on his back."

An even smaller boy approached and leaned down. He began arranging inert limbs. This way, then that.
He would step back to survey his work amidst the din of the other children.

"Is he playing dead?" I squinted.

"I think the other one is the undertaker," was the reply.

This went on for some time.
Inside that writhing landscape... slow, almost loving, movements.[4]

I dreamed I was in a dark tunnel calling out to Thomas, but I didn't know what I was saying.
Were you answered?
I came out into the sunlight and a horse stood still.
You must have been heard, then.[5]

4 This is a true story of something that I witnessed with my husband while writing this piece. It was like looking into a little landscape enframed... an existential microcosm of a world filled with vitality and mortality. Amidst the shrieks during recess, the children's silent play-acting of death rituals was riveting. This vision seemed to capture for me something that I was struggling with at the time— something that had to do with notions of the picturesque. William Gilpin's 1794 essay on "picturesque travel" describes it this way: "We are most delighted, when some grand scene, tho' perhaps of incorrect composition, rising before the eye, strikes us beyond the power of thought... [when] every mental operation is suspended. In this pause of intellect, this *deliquium* of the soul, an enthusiastic sensation of pleasure overspreads it, previous to any examination by the rules of art. The general idea of the scene makes an impression, before any appeal is made to judgment. We rather *feel*, than *survey* it." (Gilpin, 1794, pp. 49–50)

5 Don't you just love Thomas' first image? It says it all. Bucolic. Symbolic. Quixotic. Foreground. Middle ground. Background. Horse. Tower. Mountains. It is so good, and yet so bad. The "good" Swiss objects are in the foreground and background (horse, mountain), with the "bad" object (tower) in the middle ground. Mitchell has a lot to say about the fate of "bad objects" within the imperial agenda to suppress "otherness" (by destroying icons, fetishes, and totems). But what is perhaps more useful to us here is Mitchell's "replacement" of imperialism by globalization as a "matrix of circulation and flows of information without a center, determinate location, or singular figurehead." (Mitchell, 2005, p. 150) Think now of the "totemic" cell phone tower as a symbol of the indeterminate circulation matrix—an Alpine arboreal presence within "a rhizome of networks, webs, and mediascapes where the buck never stops, the telephone trees never stop growing, and no one is in charge." (Ibid) Amongst all the voices swirling around that horse, I don't think she heard a thing.

We could have gotten in trouble, but we
wanted to see the boy again. The "dead" boy.
He had lain so still in the play yard before
the teacher called the children back inside.
At the end of the school day we returned.
Who would be there to pick him up?
Held aloft in his mother's arms, his face
shattered with joy.[6]

More horses came to the field. Slowly arriving.
Soon, cows, too.
Were you still calling out to Thomas?
I saw him leaving. He was running away.
Horses and cows following behind.
And you called out to him?
No, I just called him. But he didn't pick up.[7]

[6] Let me be clear. This was a scene, not a picture. We could not have photographed what we witnessed as the child appeared for a second time. Indeed, my husband (who is a photographer), could easily have taken a photo of the little boy playing dead in the schoolyard and it would have *read like a picture* (trust me, it was all very Gregory Crewdson down there in the play pit). But not this reunion scene. This was somehow *unpicturable.* In anachronistic, but appropriate (I think) shorthand terms: it's like Thomas constantly confronts the materiality of the picturesque (horses, rivers, valleys, forests, snow-capped mountains), but *the most material* of all the objects in his viewfinder constantly defies this categorization because it is so banal and (yes, I'll say it) so sublime. *But why is a cell tower sublime?* The same way a little boy playing dead is sublime in Jean-François Lyotard's view—neither entity represents the unpresentable, but both present the fact that the unpresentable exists. The silence of death. The infinite cacophony of voices. This is the shattered face of joy.

[7] It's strange that in my dream Thomas didn't get my call since the Swiss countryside has been a testing site for Huawei's 5G technologies for some time now. Switzerland's independence of the EU has allowed it to fly under the radar in rolling out numerous private and public networks (not without opposition from many locals). The cows in my dream must have been from the northern hamlet of Tänikon where bovines have been experimentally fitted with 5G-connected neck straps that track health and productivity data transmitted at speeds almost hundred times faster than current networks so that grazing behaviours and factory outputs can be processed in real time.

Pictures want what mirrors have.
What do you mean? Like... they're jealous?
Yeah. A little bit jealous. Because mirrors have...
you know... multiple dimensions.[8]

When I'm dreaming, I can never dial numbers.
I'm just all thumbs.
I had my phone in my hand but it turned into
a rock. I just kept staring at it. Then it was
more like telepathy. I was trying to reach Thomas
through my thoughts.
What did you want to say to him?
I wanted to say "I'm here in this landscape, but
I don't know where I am." [9]

In my dream I must have laid down on the
soft grass and fallen asleep.
And then...
Engadin! Engadin!
The round words in my mouth.

I woke up with a start.

[8] Another way to think about this is that
numerals—like the ones you see here on the
page 1, 2, 3, 4, 5—are graphic objects, but
as conceptual mathematical ideas they might
be talked about as "things." Or that actual
mirrors are objects, but when they hold, reflect,
and project various entities back into the
world, their "thingness" is much more complex
to define. A lot has been written about the
object/thing relationship, but let's stick with
Mitchell again. He says: "The thing appears
as the nameless figure of the Real that cannot
be perceived or represented. When it takes
on a single, recognizable face, a stable image,
it becomes an object; when it destabilizes,
or flickers in the dialectics of the multistable
image, it becomes a hybrid thing (like the
duck-rabbit) that requires more than one name,
more than one identity." (Mitchell, 2005, 156)
So let's ask again: *What do Thomas' pictures*
want? They want to be both banal and sublime.
Those towers are objects, but I think they're
really asking to be seen as things.

[9] I'm still saying this to Thomas. "I am here
in this landscape, but I don't know where I am."

REBECCA DUCLOS
UN RÊVE. UN GARÇON. UN CHEVAL. UN MIROIR.

Engadin! Engadin!
Les mots ronds dans ma bouche.
Je sortis de mon rêve en sursaut[1].

1 L'Engadin est une haute vallée de 100 kilomètres dans les Alpes suisses que Thomas Kneubühler a visitée à plusieurs reprises entre 2017 et 2019. Présentées ici dans un ordre quasi linéaire, la série de tours commence près de la frontière italienne de Müstair et se termine dans une station de ski de Samnaun, à proximité de l'Autriche. Photographe rompu à la course d'orientation, Thomas s'est muni d'une carte accessible au public pour se diriger, mais a finalement dû s'en remettre à divers modes de transport (train, autobus, voiture, vélo, marche) pour atteindre cette série de tours passablement éloignées. Selon l'artiste, le projet porte sur « l'intersection de la société et de la technologie, la numérisation de nos vies dans ce cas-ci, encore si souvent invisible. Mon projet, poursuit-il, soulève également des questions sur le genre "photographie de paysage". Je suis allé dans des endroits que personne ne choisirait comme destination – ou comme sujet de photo d'ailleurs. Il s'agit souvent de non-lieux, qui en disent davantage sur la région des montagnes que bon nombre de vues pittoresques habituelles. »

Pour ma part, je n'ai pas encore eu le plaisir de visiter les Alpes, alors je me projette dans le monde de Thomas. Ce que je vois, essentiellement? Comme objet faisant partie d'un paysage, chaque tour est d'une solidité brutale (certains diraient vulgaire). Je vois de vastes étendues de terres typiquement « suisses » dans leur rudesse et typiquement « suisses » dans leur adhésion à l'entrepreneuriat mondial. Ce que je ne vois pas, évidemment – et ce que les images de Thomas représentent mais ne peuvent jamais saisir – c'est la transmission évanescente de données sur les communications en continu dans l'éther, tel un vent alpin intangible.
Voici ce dont je rêve depuis la première fois que j'ai vu ces photographies.

Que veulent les images[2]?

Ne veulent-elles pas ce qu'on veut tous?
Être vu. Être regardé, tout simplement.
Et si elles voulaient être regardées au travers…
et non tout simplement?
Tu veux dire comme à travers une fenêtre?
Non – à travers – comme à travers un télescope
ou des jumelles.
Nan. Je pense que c'est plutôt comme dans.
Par exemple, la façon dont tu plonges ton regard
dans les yeux de ton amant[3].

[2] *Que veulent les images?* est le titre provocateur de l'ouvrage de W. J. T. Mitchell publié en 2005 et, en sous-titre : *Une critique de la culture visuelle.* À la fin de sa préface, comme s'il était en train de regarder les photographies de Thomas, Mitchell écrit : « La piction est donc une créature profondément paradoxale, à la fois concrète et abstraite, partagée entre la singularité de ses traits individuels et la totalisation d'une forme symbolique. « Visualiser la scène » implique de se figurer une situation de manière générale et intelligible, même s'il n'est jamais question que d'un instantané, d'un moment précis où la prise de vue est capturée – qu'il s'agisse d'un cliché stéréotypique ou photographique, de l'institution d'un système, ou de la mise au jour d'un univers poétique (sinon des trois à la fois). » (Mitchell, 2014, p. 20)

[3] Les images des tours de téléphonie cellulaire font ce que toute bonne photographie fait : elles présentent un paradoxe. Du point de vue concret, on peut les regarder tout simplement, admirer leur cadrage, leur production et leur efficacité. Elles réussissent parfaitement à capter les paysages suisses, avec tous leurs clichés alpins historiques, maintenant parsemés d'infrastructures de communications contemporaines et capitalistes. Du point de vue abstrait, on peut regarder à travers ces photographies et, comme dans un télescope, examiner Thomas posté dans des endroits particuliers à des moments particuliers et, avec lui (d'après les mots délicieusement démodés de Mitchell), entendre *le déclic de l'obturateur.* Cependant, j'opte pour la binocularité et je veux fusionner ces deux façons de regarder les images « tout simplement » et « à travers elles », pour explorer comment on pourrait plonger dans ces images ou, d'après Denis Diderot, comment pourrait-on *y entrer.* Tout comme je plongerais mon regard dans les yeux d'un nouvel amant, je regarde ces photographies intensément et je demande : *Que veulent-elles?* Je crois que ces images veulent être à la fois banales et sublimes.

Il faisait soleil. Une surface entourée d'un mur et enfoncée dans le sol grouillait d'enfants de la maternelle. Nous les regardions d'en haut.

« Regarde, dit mon compagnon, ce petit garçon est couché sur le dos. »

Un garçon encore plus jeune s'approcha et se pencha sur le garçon allongé. Il commença à placer les membres inertes de manière délibérée. De cette façon-ci, puis de cette façon-là. Il reculait pour examiner son travail au milieu du tapage des autres enfants.

« Est-ce qu'il fait le mort? », ai-je demandé en plissant les yeux.

Réponse : « Je crois que l'autre est le croque-mort. »

Cela dura un certain temps.
Dans ce paysage gigotant… des mouvements lents, presque tendres[4].

J'ai rêvé que j'étais dans un tunnel sombre et que je criais le nom de Thomas, mais je ne savais pas ce que je disais.
As-tu eu une réponse?
Je suis sortie au soleil et il y avait un cheval qui se tenait debout, sans bouger.
Ton cri a été entendu, alors[5].

4 Ceci est une histoire vraie, une scène dont j'ai été témoin en compagnie de mon mari alors que je rédigeais le présent texte. C'était comme si je regardais dans un petit paysage encadré… un microcosme existentiel d'un monde empreint de vitalité et de mortalité. Au son des cris stridents de la récréation, le jeu silencieux des enfants recréant les rituels de la mort était fascinant. Cette scène sembla évoquer pour moi quelque chose qui me préoccupait alors – quelque chose qui avait trait à la notion de pittoresque. L'essai de William Gilpin (1794) sur « les voyages pittoresques » la décrit ainsi : « Nous jouissons bien davantage à l'aspect imposant d'un site majestueux, quoique d'une composition incorrecte, lorsque le *vox faucibus hæret*, et que toute opération mentale est suspendue. Dans ce silence de l'intelligence, cet abandon de l'âme, une sensation exaltée de plaisir surpasse tout autre sentiment et prévient même l'examen par les règles de l'art. L'idée générale du site fait une impression sur l'âme avant qu'il puisse y avoir un appel au jugement. Nous en *sentons* l'effet avant de l'avoir *aperçu*. » (Gilpin, 1982, p. 46)

5 La première image de Thomas n'est-elle pas merveilleuse? Tout y est. Bucolique. Symbolique. Chimérique. Premier plan. Second plan. Arrière-plan. Cheval. Tour. Montagnes. Elle est tellement bonne et, pourtant, tellement mauvaise. Les « bons » objets suisses sont au premier plan et à l'arrière-plan (le cheval, la montagne), et le « mauvais » objet (la tour) est au second plan. Mitchell est très éloquent au sujet du sort réservé aux « mauvais objets » par les desseins impérialistes qui visent à supprimer l'« altérité » (par la destruction des idoles, des fétiches et des totems). Mais ce qui importe plus pour nous ici est que, selon Mitchell, l'impérialisme « est censé avoir été supplanté par la mondialisation, c'est-à-dire par des trajectoires et des flux d'informations dont la matrice, dépourvue de centre et de localisation déterminée, n'est régie par aucune forme singulière. » (Mitchell, 2014, p. 163) Pensez maintenant à la tour de téléphonie cellulaire « totémique » comme symbole de la matrice de flux d'informations indéterminée – une présence alpine arborescente dans « un rhizome interactif et médiatique en croissance permanente; le fric n'y sommeille jamais et personne ne peut être tenu pour responsable de quoi que ce soit. » (Ibid) Malgré le tourbillon des voix autour de sa tête, je ne crois pas que le cheval ait entendu quoi que ce soit.

On aurait pu avoir des ennuis, mais on voulait revoir le garçon. Le garçon « mort ».

Il était resté étendu, si immobile, dans la cour de récréation jusqu'à ce que l'enseignante demande aux enfants de rentrer.

Nous sommes retournés à la sortie de l'école.

Qui viendrait le chercher?

Soulevé dans les bras de sa mère, son visage vola en éclats de joie[6].

D'autres chevaux entrèrent dans le champ.

Arrivèrent lentement. Des vaches aussi, peu de temps après.

Criais-tu toujours le nom de Thomas?

Je l'ai vu partir. Il se sauvait en courant.

Les chevaux et les vaches le suivaient.

Et tu as crié son nom?

Non, je lui ai téléphoné. Mais il n'a pas répondu[7].

6 Comprenez-moi bien. C'était une scène et non une image. Nous n'aurions pas pu photographier ce dont nous avons été témoins lorsque nous avons revu l'enfant. Mon mari (photographe professionnel) aurait certainement pu prendre une photo du petit garçon qui faisait semblant d'être mort dans la cour de récréation, et elle *aurait eu l'air d'une image* (croyez-moi, c'était du pur Gregory Crewdson en bas, dans la fosse au jeu). Mais pas cette scène de retrouvailles. Pour une raison quelconque, il était *impossible de la représenter par une image.* Bref, pour employer des termes anachroniques mais appropriés (à mon avis) : Thomas confronte sans cesse la matérialité du pittoresque (les chevaux, les rivières, les vallées, les forêts et les montagnes aux sommets enneigés), mais l'objet le *plus matériel* de tous qu'il voit dans son viseur défie constamment cette catégorisation parce qu'il est si banal et (oui, j'ose le dire) si sublime. *Mais pourquoi une tour de téléphonie cellulaire est-elle sublime?* De la même façon qu'un petit garçon qui joue à faire le mort est sublime, selon Jean-François Lyotard – aucune des deux entités ne représente ce qui n'est pas présentable, mais les deux présentent le fait que ce qui n'est pas présentable existe. Le silence de la mort. L'infinie cacophonie des voix. C'est le visage éclaté de la joie.

7 Il est étrange que, dans mon rêve, Thomas n'ait pas reçu mon appel puisque la campagne suisse est un site d'expérimentation de la technologie 5G de Huawei depuis un certain temps. Comme la Suisse ne fait pas partie de l'UE, elle a pu déployer, en toute discrétion, de nombreux réseaux privés et publics (non sans l'opposition d'une grande partie de la population). Les vaches que j'ai vues dans mon rêve devaient venir du hameau de Tänikon, dans le nord du pays, où des bovins ont fait l'objet d'essais de la technologie 5G. On les a équipés de colliers connectés pour recueillir des données sur leur santé et leur productivité et les transmettre à des vitesses près de 100 fois plus rapides que par les réseaux actuels. Le comportement au pâturage et le volume de la production laitière pouvaient ainsi être suivis en temps réel.

Les images veulent ce que les miroirs ont.
Que veux-tu dire? Qu'elles sont... jalouses?
Ouais. Un peu jalouses. Parce que les miroirs ont... tu sais... de multiples dimensions[8].

Dans mes rêves, je suis toujours incapable de composer des numéros. J'ai les mains pleines de pouces.
J'avais mon téléphone dans la main, mais il s'est transformé en roche. Je n'arrêtais pas de le fixer. Puis, c'était comme si je voulais faire de la télépathie. J'essayais de communiquer avec Thomas par la pensée.
Que voulais-tu lui dire?
Je voulais lui dire : « Je suis ici, dans ce paysage, mais je ne sais pas où je suis[9]. »

Dans mon rêve, j'ai dû m'allonger dans l'herbe tendre et m'endormir.
Puis...
Engadin! Engadin!
Les mots ronds dans ma bouche.

Je me suis réveillée en sursaut.

[8] Les chiffres aussi – comme ceux-ci, 1, 2, 3, 4, 5 – ont plus qu'une dimension : ce sont des objets graphiques mais, en tant qu'idées dans le domaine de la compréhension conceptuelle des mathématiques, on pourrait les qualifier de « choses ». Ou encore, les vrais miroirs sont des objets, mais lorsqu'ils retiennent, reflètent et renvoient diverses entités dans le monde, leur « qualité de chose » est beaucoup plus difficile à définir. Nombre d'auteurs se sont penchés sur la relation entre objet et chose, mais revenons à Mitchell qui écrit : « La chose apparaît comme la figure innommable d'un Réel imperceptible et irreprésentable. Lorsqu'elle revêt un visage singulier et identifiable, que son image se stabilise, elle devient un objet; lorsqu'elle se déstabilise, lorsqu'elle vacille au cœur de la dialectique de l'image multistable, elle devient une chose hybride (un lapin-canard), qui exige plus qu'un nom ou qu'une identité. » (Mitchell, 2014, p. 170) Alors demandons-nous encore : *Que veulent les images de Thomas?* Elles veulent être à la fois banales et sublimes. Ces tours sont des objets, mais je crois qu'elles demandent vraiment à être vues comme des choses.

[9] « Je suis ici, dans ce paysage, mais je ne sais pas où je suis. » Je le dis encore à Thomas.

REBECCA DUCLOS

ROMANA GANZONI

Rebecca Duclos' serpentining career has toggled between academe and the cultural sphere with "off book" forays into archaeology, sheep herding, and chefing. Late life degrees, global itinerancy, independent and institutional appointments, and some recent art school deanships have characterized her path. With a PhD in Art History and Visual Studies from the University of Manchester and an MA in Museum Studies from the University of Toronto, her undergraduate degrees are in Classical Studies and Near Eastern Archaeology. She is a certified death doula. Rescued greyhounds are a constant. She is writing a play.

Romana Ganzoni crawled out of a blue handbag in Celerina, Engadin, Switzerland, in 2013, multilingual, with a text in her hand. Since then, she has been writing short stories, novels, poems, essays, and op-eds. Not even her pug Lulu can stop her. Her most recent publications are *Tod in Genua* (novel, Rotpunktverlag, 2019), *Die Torte* (young adult fiction, da bux, 2020), *Vent per mia vela* (poetry, Uniun dals Grischs, 2020), and *Magdalenas Sünde* (novel, Telegramme, 2021). Ganzoni has received several awards, including the Bündner Literaturpreis 2020. The short story *Der Kanister* (The Gas Can) mentioned in the text was nominated for the Ingeborg-Bachmann-Preis in 2014.

Die verschlungenen Pfade von Rebecca Duclos' Laufbahn schlagen Serpentinen zwischen der universitären und der kulturellen Sphäre. Streifzüge jenseits von Buchpublikationen haben sie in die Archäologie, die Schafhüterei und zur Kochkunst geführt. Akademische Abschlüsse spät im Leben, Globetrotterei, freiberufliche Tätigkeiten und Anstellungen bei großen Institutionen haben diesen Weg bestimmt, zuletzt als Dekanin mehrerer Kunsthochschulen. Sie promovierte in Kunstgeschichte und Visueller Kultur an der University of Manchester, erlangte einen Master in Museologie an der University of Toronto und machte Bachelorabschlüsse in Altphilologie und Vorderasiatischer Archäologie. Sie ist eine zertifizierte Sterbebegleiterin. Adoptierte Windhunde sind eine Konstante ihres Lebens. Derzeit schreibt sie an einem Theaterstück.

Romana Ganzoni ist 2013 in Celerina/Engadin, Schweiz, mehrsprachig aus einer blauen Handtasche gekrochen, mit einem Text in der Hand, seither schreibt sie Erzählungen, Romane, Gedichte, Essays und Kolumnen, nicht einmal ihr Mops Lulu kann sie stoppen. Zuletzt erschienen *Tod in Genua* (Roman, Rotpunktverlag, 2019), *Die Torte* (Jugendbuch, da bux, 2020), *Vent per mia vela* (poesias, Uniun dals Grischs, 2020) sowie *Magdalenas Sünde* (Roman, Telegramme, 2021). Ganzoni wurde mehrfach ausgezeichnet, unter anderem mit dem Bündner Literaturpreis 2020. Die im Text erwähnte Erzählung *Der Kanister* war 2014 für den Ingeborg-Bachmann-Preis nominiert.

THOMAS KNEUBÜHLER

Thomas Kneubühler was born in Solothurn, Switzerland, where he spent the first years of his life on a convent farm. He was active in Basel's cultural scene (Neues Kino, VIA AudioVideoKunst) before moving to Montreal, Canada, where he graduated from Concordia University's MFA Program in 2003. Since then, Kneubühler has pursued a research-based art practice including fieldwork in remote locations and on sites where access is restricted. Addressing questions of power, the exploitation of natural resources, or the effects of new technology on society, his work has been presented internationally, most notably at the Québec Triennial at the Musée d'art contemporain de Montréal, Centre Culturel Canadien in Paris, Kunstmuseum Bern, and at Le Mois de la Photo à Montréal. His video work has been screened at a wide range of festivals, among others at the Solothurn Film Festival, Les Rencontres Internationales Paris/Berlin, Videonale.15 in Bonn, and the Montreal International Documentary Festival RIDM. He received the Swiss Art Award in 2012, and was a research fellow at the Centre for Advanced Studies (CAS) in Sofia, Bulgaria, in 2018.

Alpine Signals started to take shape during a residency at the Fundaziun Nairs, Scuol, in 2017. It follows his previous project *Landing Sites,* where a transatlantic Internet cable served as a starting point to reflect on the change in communication speed over time. Thomas Kneubühler lives and works in Montreal, sometimes in Basel, and visits the Engadin on a regular basis. He knows the Alps from hiking with his father from an early age, and from cycling over many mountain passes.

Thomas Kneubühler wurde in Solothurn geboren und verbrachte die ersten Lebensjahre auf einem Klosterbauernhof. Er war lange in der Basler Kulturszene aktiv (Neues Kino, VIA AudioVideoKunst), bevor er im Jahr 2003 in Montreal, Kanada, sein Studium an der Concordia University mit einem MFA abschloss. Seitdem arbeitet er mit Fotografie und Video an künstlerischen Langzeitprojekten, die umfangreiche Recherchen an manchmal schwer zugänglichen Orten beinhalten. Seine Arbeiten, die sich mit Fragen zu Macht, Landbesitz oder den Auswirkungen neuer Technologien auf die Gesellschaft befassen, waren sowohl in Europa wie auch in Nordamerika zu sehen, unter anderem im Musée d'art contemporain de Montréal, Centre culturel canadien in Paris, Kunstmuseum Bern und auf der Québec City Biennial. Seine Videoarbeiten wurden auf zahlreichen Festivals aufgeführt, unter anderem den Solothurner Filmtagen, den Rencontres Internationales Paris/Berlin, der Videonale.15 in Bonn und dem Montrealer Dokumentarfilmfestival RIDM. 2012 wurde er mit dem Swiss Art Award ausgezeichnet, und 2018 war er Stipendiat am Centre for Advanced Study (CAS) in Sofia, Bulgarien.

Alpine Signals nahm im Jahr 2017 während eines Atelier-Aufenthalts in der Fundaziun Nairs, Scuol, erste Gestalt an. Es knüpft an sein vorheriges Projekt *Landing Sites* an, eine Arbeit über die Beschleunigung der globalen Kommunikation, bei der ein transatlantisches Internetkabel im Zentrum steht. Thomas Kneubühler lebt und arbeitet in Montreal, manchmal in Basel, und besucht regelmäßig das Engadin. Die Alpen lernte er in jungen Jahren durch Bergwanderungen mit seinem Vater kennen, und auf Radtouren über viele Alpenpässe.

ACKNOWLEDGMENTS

This book would not have been possible without all the people who were willing to team up with me. I am very grateful to Romana Ganzoni and Rebecca Duclos who accepted my carte blanche, and responded to my photographs with two extraordinary texts. Sibylle Ryser who guided me through the book-making process from the very beginning, and even more important, gave the book its fabulous design. My passionate translator team, Chris Salter, Jacqueline Dionne, and Anke Caroline Burger who made sure that the texts will be enjoyable in more than one language.

I would also like to thank the many people who were willing to give me thoughtful advice, or helped me out whenever needed. In particular my artist friends Jessica Auer and Velibor Božović, my family members Laura Fuchs and Margaretha Kneubühler, and also Walter Bernegger, Stella Händler, Thomas Hofmann, Luke Reid, and Nicole Zachmann. My special thanks goes to Maia Iotzova who has always been there for sensible feedback, encouragement, and support, even at unusual hours—Благодаря!

My gratitude goes to the Fundaziun Nairs and their residency program, to the Milieux Institute for Arts, Culture and Technology at Concordia University, and to Silvia Jaklitsch at the Verlag für moderne Kunst for believing in my project, and also to Gabrielle Cram and her team for their editorial support.

Alpine Signals received funding from the Conseil des arts et des lettres du Québec, the cantons Solothurn, Basel-Landschaft, and Graubünden, Mary und Ewald E. Bertschmann-Stiftung, Georges und Jenny Bloch-Stiftung, Kresau4-Stiftung, and Scheidegger-Thommen-Stiftung.

IMPRINT

Alpine Signals
Twentysix Cell Towers in the Engadin

Photography: Thomas Kneubühler
Texts: Romana Ganzoni, Rebecca Duclos
Editor: Thomas Kneubühler

Translation: Chris Salter (D→E), Jacqueline
Dionne (E→F), Anke Caroline Burger (E→D)
Copyediting: Michaela Alex-Eibensteiner,
Martina Buder, Eva Helmreich, Anna Mirfattahi

Graphic Design: Sibylle Ryser, www.sibylleryser.ch
Typefaces: Arnhem (Fred Smeijers), Gotham Narrow
(Tobias Frere-Jones), Neue Aachen (Jim Wasco /
Colin Brignall)
Paper: Profimatt 170 gm^2, Munken Lynx Rough 150 gm^2
Printing and Binding: Eberl & Koesel GmbH & Co. KG,
Altusried-Krugzell, Germany

VfmK Verlag für moderne Kunst GmbH
Schwedenplatz 2/24, A-1010 Vienna
hello@vfmk.org
www.vfmk.org

ISBN 978-3-903796-98-0
Printed in Germany

All rights reserved
© 2021 Verlag für moderne Kunst and the authors
© Photographs: Thomas Kneubühler
© Map p. 71: swisstopo
The work by Thomas Kneubühler is under a
CC BY-NC-SA license:
https://creativecommons.org/licenses/by-nc-sa/4.0
www.thomaskneubuhler.com

Works Cited in Rebecca Duclos,
A Dream. A Boy. A Horse. A Mirror.
W.J.T. Mitchell:
What Do Pictures Want? The Lives and Loves of Images,
Chicago: University of Chicago Press, 2005.
Que veulent les images? Une critique de la culture visuelle,
Dijon, Les presses du réel, 2014.
William Gilpin:
*Three Essays: On Picturesque Beauty; On Picturesque
Travel; and On Sketching Landscape: To Which is Added
a Poem, on Landscape Painting.* London, Printed for
R. Blamire, 2nd ed. 1794 (1792).
*Trois essais sur le beau pittoresque ; sur les voyages
pittoresques et sur l'art d'esquisser des paysages, suivi
d'un poème sur la peinture de paysage,* Paris, Éditions
du Moniteur, 1982.

Distribution
Europe: LKG, www.lkg-va.de
UK: Cornerhouse Publications,
www.cornerhousepublications.org
USA: D.A.P., www.artbook.com

Bibliographic information
The Deutsche Nationalbibliothek lists this publication
in the Deutsche Nationalbibliografie; detailed
bibliographic data is available at www.dnb.de